To Mommy
Sofia
Love you

Self
Executioner

(SOUL DISSOLVER)

paintings & poems

by
Celeste Zeta-Montalban

REGENT PRESS
Berkeley, California

ISBN 13: 978-1-58790-471-4
ISBN 10: 1-58790-471-3

Library of Congress Control Number: 2018968572

ACKNOWLEDGMENT:
To Mark whose enthusiasm for
putting this book together facilitated its birth.

Manufactured in the U.S.A.
REGENT PRESS
Berkeley, California
www.regentpress.net

I've always felt the hunter was an image of the artist. The artist is a hunter, and God is a hunter, hunting us. We are always being looked at by God, by the hunter. In my studio, I am in the eye of the hunter.

— MEINRAD CRAIGHEAD

Table of Contents

Introduction

Celeste is one artist who at times with a passion that is insanely possible, is able to translate the narratives of her poetry to her paintings and vice versa. Amazingly, she captures an awareness that otherwise would only dwell on the mundane. As such, she can creatively tiptoe around her artistic pursuits, i.e. painting, writing, music, and like she said , she can escape from herself and her intent of the moment and not feel bad. She can move forward in relentless pursuit of her artistic domain much like her path is devoid of any human marker. "Aevum amica meae." Latin phrase which means my soul mate. A glimpse into the totality of her immersed in her arts affords me a feeling of endless exuberance. Her artistic sensibilities enhance the mystical and emotional side of me. The magical rhythm and depth of her poetic lines always lead me to the path of bliss and wonder. I have seen her emerge from a solitary emersion in her artist's cocoon as I call it, with a work of art the mystery of which seemed to me like she had been able to resurrect rubbish or something sinister and heartless into a beautiful masterpiece. That's my soul mate who, when she talks about a mere fly by the window pane, that fly becomes an insect to behold. So I am doubly sure, this book will take us into another journey of wonderment and joy.

— *Lourdes Belgica-Yambao*

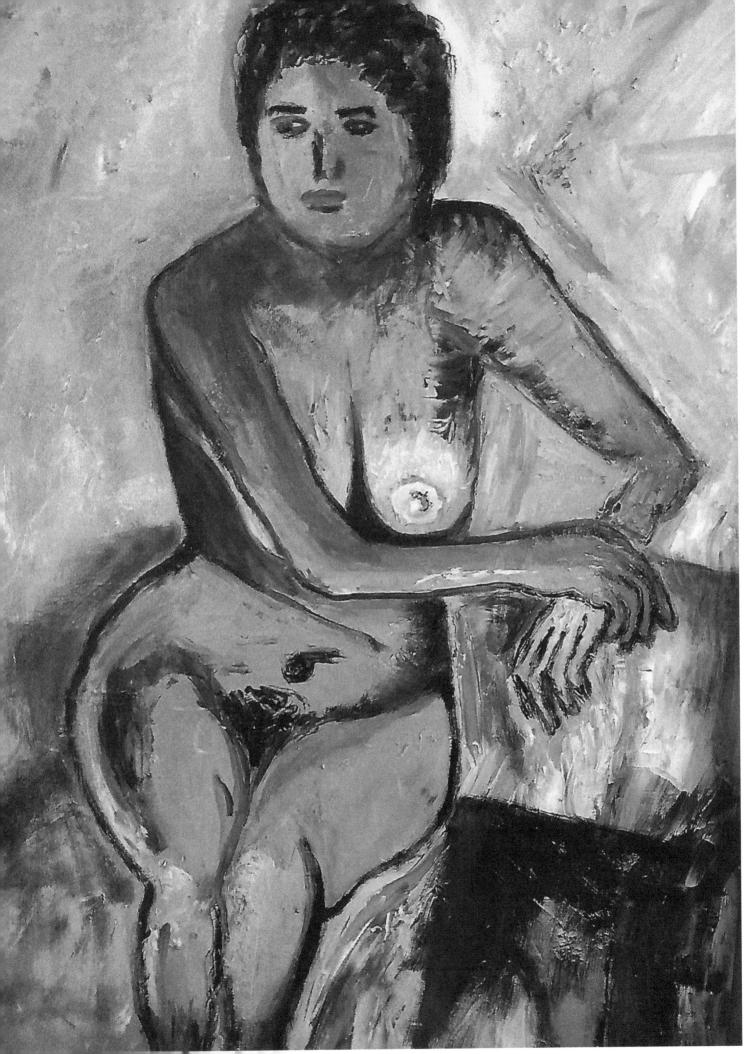

Self Executioner
(Soul Dissolver)

Luciferous darings — like some friends would say — angelic musings like my
mother would spell out — launch thoughts to clean out
what spells the shadow of a tyranous entity in self destructive
moves empired to leave one or them a note to say
death claims a wise brain-work so
in white paper and black ink
is resolved a glorious
scene of one's own beautiful exit..
Glorious sunset integrates with a monkey wrench or a golden
bullet or a rope for the neck
to end it all and to journey on into an
uncertain field of snow drifts or grass- covered
valleys or just plain nothingness
we can only humanly conjure
(et locus non est in anima esse putatur existere
confirmavit existit)
and the soul is supposed to exist in a place no one has confirmed exists
what is to roam lonely?
what is to run around locked
in one's terrifyingly unresolved distress
that deeply latches on to every
embattled cell and bone?
eyes cry till they hurt enough
heart bleeds with the red violet spray in a
final show of airless wriggling
mouth unspeaking momentum that gathers
like a storm's eye on the roam
now courage overtaking an insane but peaceful
resolve to embrace peace, no matter the anger
no matter the tightly silk- wrapped depression
no matter the hate that eats out every fiber of the human content
that is all mine to embrace and feel
ictus brave tales to wash off every rot that
makes the body sick like
in an airless room it knows nowhere to blurt out
remains of every woe piling on
piling on
piling on
inching murderously into bones

till surely a heap of leproused flesh
cocktail of stinking emotions that can no longer sustain
dregs of what in abandoned alleys are found no more space
only dark stones taunting at every
thought meant to validate and justify
brutal blows to the heart

cry for help muffled, never to be heard again
consciousness pressing a pass through a vaginal tenderness
the birth canal once more pain discarded, now a
sickening knowing wrapped in doubts no more
blood timed eagerness a paradox
stuck in limbo
am I prepared to leave?
still the answer an astounding yes
the end is reached there's no bend no turning back
I may embrace the light or a certain
cloak of darkness what is there
to expect?
Nothing but an unctuous human relief
an eclipse, a grand entrance to a new set of
baptismal fire, I suppose?
But this is all I know to end deathly tentacles that bury and
suck out all that should be happy in me
prick and cause so much my soul to bleed
an ache so undefinable
a torturous, murderous
hell fire that sears, wiry knots that grind
they were born with me, tightly intact in my crib so
to prepare parcels of life's excruciating pain
and finally in calculated hours
one day I can be my own judge, timetable for release and
be my own executioner thus depriving
God a smirk when my time's up
or hand Him a line which says I am of my own
time lined volition free
I suck out my own soul
dissolve my thoughts
that in eons will float in
meaningless space who knows?
(mortis in mortem pulchrum est)
some asserted and so
in my mind God seems to agree.

Two and a Half Dozens Haiku

Catch the drift now
first round of applause
say tough words
then crucify.

Not knowing when to glance
gloat not at one's lowliness
we will all die.

There is no need for
someone to see things
using lens other
than his.

Filter not cup the sun
in its eternal roam
a fearsome friendship

Insulting than redeeming
infidelity and cupped tea
now cold.

Glassy eyes why so
unsung mysteries
ordeal of being dead.

He rocked in chair
dead for years
chair stays Father
sits in it still.

Various mediums art
hidden contained in
psyche we can never tell.

Starve yourself fasting
for whom and how
you an atheist
but why?

Gather morsels
sore mouths to feed
start fiery fire
seek the unborn.

You are just a figment
truth to dissect
secret passages you
will take.

Don't like this peg
square not round
turned fast it hurts
bury it.

Again and again a flat
sharp music manipulates
no nonsense.

Cut your skin
saw layers deep
skin deep beauty
which one have you?

I sleep priviledged
walk with gods we relate
meanings deeper dreams

Pray for each other. Stop
failures trapped in
wasted tears. Rejoice now.

To love. We should shoulder
weight belted hissed songs coil
listen silent heart.

Dipped my feet.Cold water
unprepared nerves shocked
universe but no fuss.

Begging bowls hands
holding hearts we thrive
curled in cracked bowls.

Climb to summit road
where wafts smell of rotten
air blows from man land.

Rabble-rouser says double
only when alone
I cannot stand it.

Threat of clouds dark
engulfing all humans
wars of man against man.

Incessant laughters
from search lights within
feel happy but not quite.

Running here to there
encounter evil-looking
strangers who prey.

Sounds of glass breaking
astounding sameness
swift break dawn gliding.

Cupped ears hear
whimsical music in
glazed room where
love is happening.

An air of descent
the nude curves
thrown ahead uncertain
arch of grace.

Invisible force it lies
pull of shadows severe
lenses dimming.

Need extra meanings
a quiet reply
keep mum if
unsubstansiated.

I heard the sky crying
problem it would be
if rains forgo its purpose.

A Stare

get rid the lurking donnage

then go slowly and weave

yourself within an artist's fabric

deciphering non-essential forms

so as not to intimidate inventions

better search muted notes in your soul

then engage the bristles and brush to

draw hidden but unforgotten narratives

enriched with coded colors to try to

interpret long covert languages

of lesser gods through solid crypts

that tear and run the gamut of shame

when in past times you thrust

shameless nakedness in order

to book next modeling time.

A Canticle For Light

My genesis Oh God: a betrayal of

Vision of a very ancient Moses

Abraham, a pendulum to many races.

An abscess in anguiushed sigh behooves

Me wake up hastily so as to contemplate

Eternal source of well kept aged wound.

I cannot sleep while struggling isms

Indomitably itch, hurt and moan.

There is an urgency to incubate my

Atoms in thy time-polished grand halls

Where acts of Absalom must be.

Let our hearts be made accessories

When the lion with its soundless steps

Slew the dragon in its deep slumber.

There are canticles to keep and mind

Held in nights when great men's hearts

Will go still before their deaths.

Their bodies will be thrown amidst

Lulling smell of a placid river

Where John spoke of a holy baptism.

I tremble at the thought of my soleness

Everyday I gaze at eloquent muteness

Of an overflowing Babylon riverbanks

Where floated heavy marks of Zion

As my canticled quest takes me to summit

I must fear the lonely nights when an

Abandoned hope may succumb fast

To a mire that lies cathartic to purging.

Deafen me to distant thuds of

Abysmal and unexpected falls.

Where then is our rightful space?

Even among ancient nenuphars

Ethereal bodies are just ciphers.

In youth, innocence was once a

Peaceful portion of an age

Resounding, firm, unretreating

So when branches of fig trees

Finally rests its time- capsuled

Rendezvous with every season

For gentle fruiting calm giving

Cup sun's fire only to spew ciders

Into our beady eyes will be tears.

Sure phrases of weakened faith burns

In soft breasts of vigilance staring

Asserting an unsung existence

Sinning always sporting repulsive eye.

Ultimately serpentine tongues wag at

Weak spots of an extremely lonely man.

So cup when empty, fill it fast with

Cooled waters from the spring of One's

Often doubted Love and Omniscience.

A Different Route

the purplish curious face
wearing diaphanous skin
exhibiting nothing but
shallow material schemes
thick blue blood tamed not
by saliva sealed covenants
but by vein curdling blood
owned by discontented piulgrims.

black iris of his eyes that
circle and circle around
different routes expanded
field of vision widened by
self gathered power points
comfort zones dumped
but never gazed never seen
only through brave hearts.

there is a great pulse
a knowing from the breast
where desires for a leap
arise unhindered by fear
a keen eye on the guard
unlovely war songs sung
expressing essential forms
to advancing pilgrim souls.

A Poem For Segko

Gather some lights Segko

Pocket them you will go

For you to use when

Frenzied nerves shall

Need be nourished well

As they turn very pale

When severely mocked

Abused they assume some

Demised form sustained

Poses then poked wildly

Strength had been fingered

Out of place till ego faded in

Shame it hid so badly frayed

Segko there is nourishment

Available for a great need

You see you have an ailing

Arrogance and rotten pride.

A Ghost

yes a ghost

just a ghostly

holding on to

the sin's eye

it cannot be

haunting with a

faint lamp

cause the lamp

doesn't sketch up

thumbnail remembrances

elusive as eye of

a passing storm

the resolve that

one day we catch

up or it will with us

our hidden dark secrets.

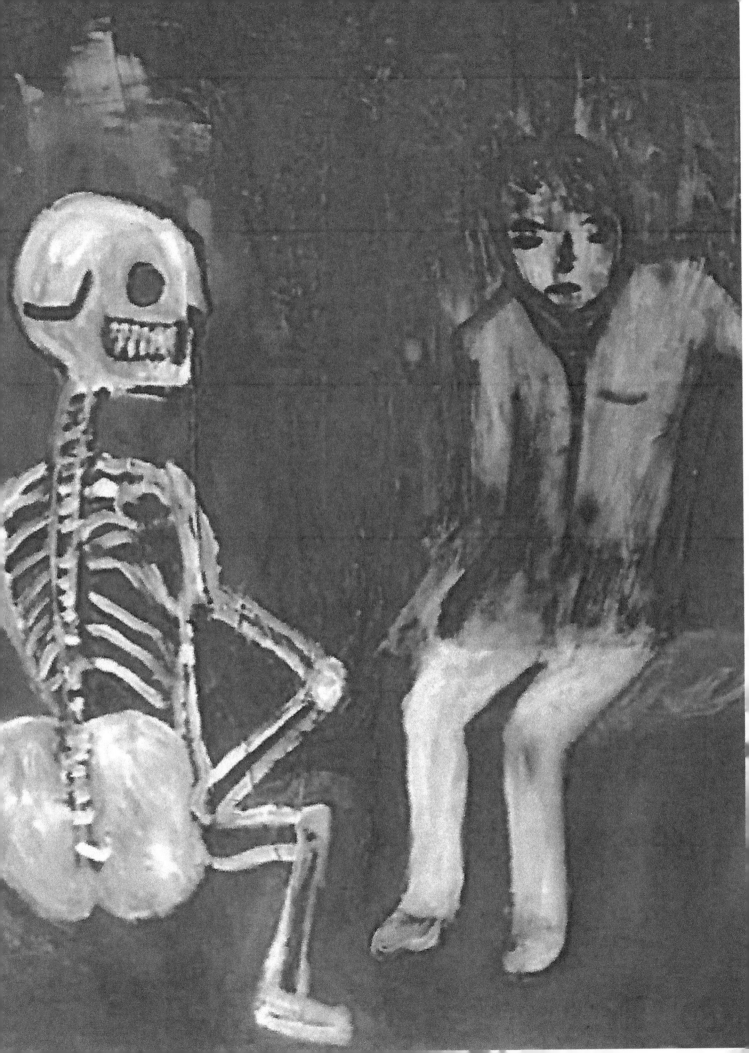

A Spot

Unfold me, give me a spot
beyond anyone's reach
I need wings to lift me off
unmarked places where my
Thoughts are perched on my
eyelids heavily unopened
torrents of a savage rain
Then my steps, they will
carve footsteps in clay
So sordid ancestral stories
be marked concocted.

Aberration

When hell broke loose a terrible cuss escaped many lips
setting fire upon everything soft a pillowed cotton eased up
wired dreams spewing the watery smell of camphor melts
taking over round plain hairballed toys for my cat BlimBlim what mistake
can a cannonball make to roll into a threesome doing mostly adult stuff misallied
nonsense in every mood an aberration do we still ride donkeys at night
when the
heavy smell of boredom comes on strong inviting a partake naming a
shame a justified game that runs through the long night when our breaths
smell of random call for rain to wash away sludges clinging to our rain-soaked
shoes banging so noiselessly on the pavements of strange places tapping
fast in covert crevices even in parked cars where dreams crawl and hide
and take their last refuge.

Addressing My Whys

Vague darkness some souls — must not hasten into — without water lights
to reflect to illuminate — life paths contained — in golden fleece — refined
blood lines with — the burden slow to — disembowel to tell — somber
symmetrical tales taken — from subdued grievings — solemn pristine joys
smooth foot falls — trickling down — lonely demise of — mortal weary minds
are not previledged to — conjure broken dreams — arising from emperic
forms — who knows what they mean — a long fought struggle — a wreath laid
at midnight...a wretched life line — to hold on to...for ancestors to share
so living can carry on — stoic tales where — speechless gazes hasten — into
remorseless territories — where egos bloat and dwell — spider-laced cracks
the hell it is that — pours blood into — tormented souls...until we learn frail
hearts in its miserable — brokenness goes uncharted — because there is so...
much to explain — to lay blame — so much to unburden — though we know
we are alone in certain — journeys to plains and — valleys our broken
selves to accompany — we never shield the truths — undeclared till they hurt
we deal with our own — lonely whys alone — until safely the energy — that
oozes from core of — the heart's dark chamber — becomes a breath — becomes
our reality — becomes the truth — a release.

...artistic endeavors such as painting, poetry, sculpture or

composing music sometimes are lonely journeys for the artist

because the muse's comtemplative spirit which accompanies each

artistic undertaking coldly refuses ro have anything to do

with humanity...truth is the muse simply wallows in bounteous

inner subtleties which lean solely toward self-gratification...

or daemons which propel the artist to follow where they lead

...these daemons don't have the inclination to integrate into artistic

works social ills which the artist sometimes feels he has

the moral obligation to integrate into his works...confused but

delightfully so, the artist thus remains a most misunderstood creature

...a mad entity in a chaotic world...

As Dreams Recur

As dreams recur
Then I, soundly asleep
Walk into every bit
Of a morbid scene.

As dreams recur
My half-tired body
It forms alliance with
A strengthened awareness.

As dreams recur
Night's remains leak into
Undersides of rocks on
Stories only told in bed.

At The Breakwater

Sitting before its vastness I
bleed me mysterious isms
to a still communion with
sea's gently heaving slopes
uncracked surface urging
waves to break and race the
endless race of eternal time
 unleash the whispers
can one decipher? Can one tell?
 you are never a friend
 never an honest revealer
 vast ocean hinged truths
of man's uncertain fate I
hash my own oceantides
closing my eyes I bid me my
heart to decipher your no
ending no beginning cycle
of mysterious existence
 your lyrical sounds
 seeks but never soothes
sitting still I surrender me
to the quietness of your future
dreams forcibly encompassing
receptive surrender to my own
inner seascape whose salty waters
verily contains hidden passions
and the pulsebeats of your own
 my mystic bid for silence
 you assail with detached
 coolness as you playfully
 coil around my ankles

you turn my feet into an alchemy
when you baptize me in morbid
stance as you feel passionate bids
to preserve our own survival scheme
we decide to regrow anchoring roots
despite approximations of your and
my own humanly distanced elements
 I am then transformed
 as I humbly slide down
spine of disowned hopelessness
I can strangely move against you
but you cannot come to me because
my internal ocean reeks with laughter
against your unfathomable secrets
we can laugh and sing together
 I can even move further
 down your liquid heart
I can sing you a lullaby
and show you what real
tears can do to a sighing
soulless rendevouz with
death at midnight

your remote indifference intrigues me
but like it is, we can stalk each other

take me into your bosom and cuddle me
as I lay down looking at the skies.

Backing Away

where do I find you
seeking to loosen every
strand of eerie silence
that keeps popping up

on my wind-swept hair
knowing no language to
transform secret thoughts
into delible distress signs

how can I give you warmth
when mostly you retreat
into discreet trails that bring
you away from my grasps

we cannot trek together
existing solid boundaries
when you don't trust enough
depth of my submission.

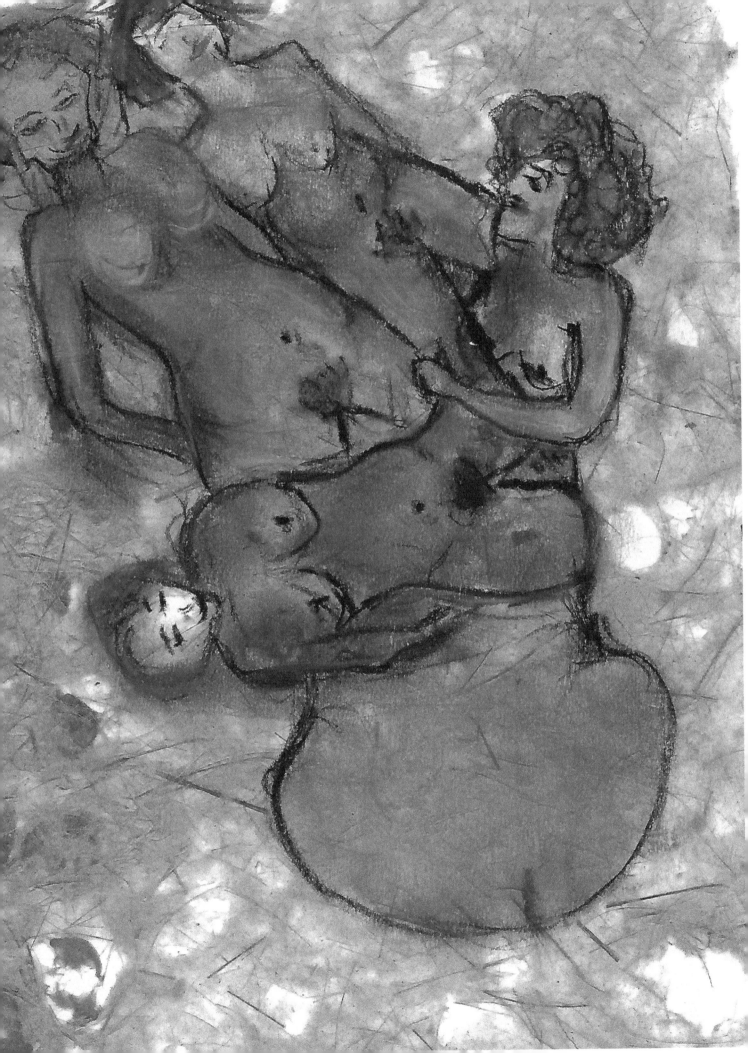

Blank Spaces

I serve me my breakfast at six
in a double lid bowl my breakfast
consisting of the night's lilting lines
of poetry shaded red many grays
dancing footless people carving
pictures against the aghast silky
glide of sky and trees and twigs
and moonless minds drinking the
heat of noon many drying junes
serve me my next breakfast at six
a plate to break a glass to hold a
sinking brain that recognizes no
more lapses nor remembrances
a blue tea cup that shouts shrilly
it cannot hold any heat no more
it comes from a molting hole in
nook of atom-structure filled sky
my breakfast on a cold six oclock
morn i see on my cold plate dying
lines really frilly lines that know
they are just excesses leaving no
spaces for some weak poetic lines.

Cornfield

In cornfield strewn with water holes

I dipped my feet

to cool

my feet they urged me carry my body fast

cause they wanted to feel inviting

cool in waterholes

but only if I dip them fast

enough to drive engulfing heat from top

of head to tip of feet

then walked so fast not knowing

lessons in cornfield true

dipped my feet in waterhole so cool

it stood me to think even

in cool cornfield strewn with imaginary

waterholes we can dip our feet

and keep them momentarily cool.

Cosmogenesis

(still for Lulubelle an artist friend of mine, RIP.
in your ethereal journey I am sure you don't mind
wearing the
garment you love to wear)
Darkness with full essentials.
 There are, like you said
many laid away untouched patterns
faultless, precise math juxtaposed
in our imperfect unframed art.

Meanwhile and noiselessly
an atom slithered on tension of
an accommodating water surface.

Molecules conspire like
tangled noodles in spate
so challenging.

But darkness still persists.

Cool fires
spit out myths that nobody
weakly believes will profit

divine coagulation.

And then it was drcided.

For the mind till ages past will
conceive glamour in wines
without dark conflicts.

Only passive heritage.

Commanding,
no fools shall awake resting
desire of dreams in any
chosen form.

Vicissitude, harmony, then chance.
Power rules
till skies and good earth
get done with confessions

Try eternal summit soon
Now your cosmos
evey floating bit of you
how will your uncommom
brains rewire the fate
you chose or unchose?

You once said that dying
means tying the umbilical
cord around your ego-
destined consciousness.

Smart like nobody from
the alley or the bloody
gutters of past ages you
will seek and gather dusts

Dusts are always fine and
powdery and lustfully ticklish
like muck unwashed.

What minds now Belle?

You have no choice but
to coagulate and form your
own eternal self part.

Covert Moves

Let me collect pestilence infested

droppings from heavily twisted

meridianed space skin wrapped in

exposed body assembled by a hundred

silent angels conniving to taste the

flesh of a man standing by a john.

who knows what it is to sing some

arpeggios from an opera that's been

sentenced to die on shoulderblades of

women embracing their lowliness

even when become ignominiously

hushed and left to think no more.

someone knows the secret bud hidden

in every sin hardly defined thereby

unacknowledged by eyeing hard liners

for perfections now lying in oceanfloors

never iron cladly justifying every move

every pained pirouette while executing tip

toed moves that spell murderous tricks.

Dark Suits

into dark suits laying by-----issue empty bodies-----float swiftly
stealthily from nowhere-----wanting slids into-----taunting suits
as if in ambush-----in wait for bodies-----slid into and rest-----
long unused scalpels-----appear seeking hands-----of masters hid
lost in shadows of-----knowledge fiercely ---- cut in each suit----
lost in each suit----gobbled up in each suit----marks lost no cost
truths seeking refuge-----elsewhere where----no one declares
blocked refuge-----dark suits symbolizing-----shells ready to
take new life-----to take new forms-----are we to believe-----
another round -----twisted sacrifice----no one has stated ----
another set of patterns-----another life-----nothing to contend
with-----no lies to swallow-----rammed down our throats-----
what can we do----beguiling patterns ----to camouflage------
displaced pieces sure-----to fall into place-----existing puzzles
still no truth to declare-----still are hidden-----this to deny----
this to believe-----inside dark suits are-----delicately designed
or intricately summed----up to digest-----bulk of shit.

Dark Wall

There is a dark wall we confront everyday. Written on it are things we have to unveil and deal with persistently as we go through our daily rounds of things. Oftentimes, we uncover self-destructive patterns which catch our consciousness and which lure us into its inviting uncanny folds. Most patterns allow us to experience rushes of adrenaline which admittedly most humans find so addictive. We wrestle with them to the point that we fail to see patterns which show us different potentials. They are woven the other way and are extremely calm and joyful. Sadly, we have the tendency to linger more on the maliciously sad patterns. We get so fascinated by the fiery energy we derive from them and because they can in their agitated nature offer the ideas of feeding deflated ego which we submit for others to silently validate for our own social needs. We then miss the great opportunity to catch on the happier patterns with their light and easy energy. We remain facing the dark wall simply because we were not keen in going the other way.

Delvings

Dont let the devil speak out your thoughts nor wear your clothes when you think you are humbling yourself. If you do, you blurr the line between false humility and genuine pride. Anyway, people will notice because your countenance will give you away or your feet will keep tapping on the spot where you stand.

You don't speak another man's reality and expect people to understand. You cannot representatively speak nor fabricate lies for others based on your own interpretation of an ensuing situation. Other people's stand point are not what you think they are or what they should be. At any rate, who says one can have a simplified grasp of multidimensional realities? No one is authorized to read another person's mind. That would be bullwhip. Emperical realities don't always appear as honestly as you may perceive.

El Cuerpo de Cristo

Shout loud "el cuerpo de Cristo" — a fantastic narrative —
to comtemplate — like one slanting sere leaf — to hunt some
withered plants in — unfettered waters — hoping against
hope it is a defunct — drifting faith where — mortals walk
on trails that spill no truth — .only lid-tight doubts — then
a grateful sigh — a flicker's call where — the suffering
body which spews only — half the truth lays — dead
in every confessional box — in every doubting head.
Shout loud " el cuerpo de Cristo" — then climb steep
phantom mountains — .to restore hopes — .nearly lost
nearly shattered — then take it if it comes — biting us
the glorious bite — of make believe — we should only
harness perilous but — natural rituals — mindless
obnoxious — mind-boggling — to wrap around —
questions posed — cold as malcontent of reason —
of all fibers stubbornly woven — into "el cuerpo"
in long ago born ones that — don't need relearning —
so as not to comprise — long acquired beliefs.

Evolving Form

It's a definite nowhere

Naked bodies spilling facets

Of multiple realities stuffed

Sometimes ravished amidst eternal

Changes found in missing hours

That call for excruciating long

Travels on paths beckoning on

Insisting perfection collated casts

In symmetrical forms catching

Freedom only where exposed

Imperfect bodies are readily shown

In waiting loops and dips in colors

Dripping art from artists' brushes

Sketching every formless form.

Father's Feet

My father's feet atop a coffee table

glaze smeared coffee table

his feet resting there was locked

only in my straying thought

I wondered

was confused but true

my father's feet atop a glazed coffee

table was real

unfeeling feet blue and dead

caused me fierce heartache

with innocence pronounced

eyes could only watch

my heart was just en route

to a full break

I could hardly comprehend then

truth on top of glazed coffee table

up till now partly understood.

Excerpt from an article for an upcoming book titled

"*Mysterium 11*"

by

CELESTE ZETA-MONTALBAN

It was an exhilarating moment to dwell between anxiety and forced acceptance. I was diagnosed with breast cancer. All at once everything seemed to end up as an embrace of specific formulations of a higher dimension. I tried inventing a euphemism for death. Tried thinking "beautiful transformation." Deeply, I started to look within myself for intimidating roots to parallel my growing fear. Found none. Life starts with death. Facing certain onslaught of death calls for a unique manner of dealing with it. By dint of acceptance, I tried seeing it as man's "true nature". For every new leaf greening vigorously, are browning ones in their essential nature of brittling, and finally wilting away from the stems, then falling into the ground which welcomes them. I futilely summoned calm till it became cumbersome, tiring and unlovely, till my hope dispersed away like wisp of smoke. I couldn't turn any other way. Then the ultimate litmus test for my faith. I had to go into every medical process fearlessly and executed a dance that was in sync with the inner life of the universe. My spiritual sensibilities collapsed against what was unacceptable at the moment. I tried to look at things from different perspectives. We can cheat The Great Reaper if we momentarily choose to.It's very humbling but believe me there's another prayer for it.

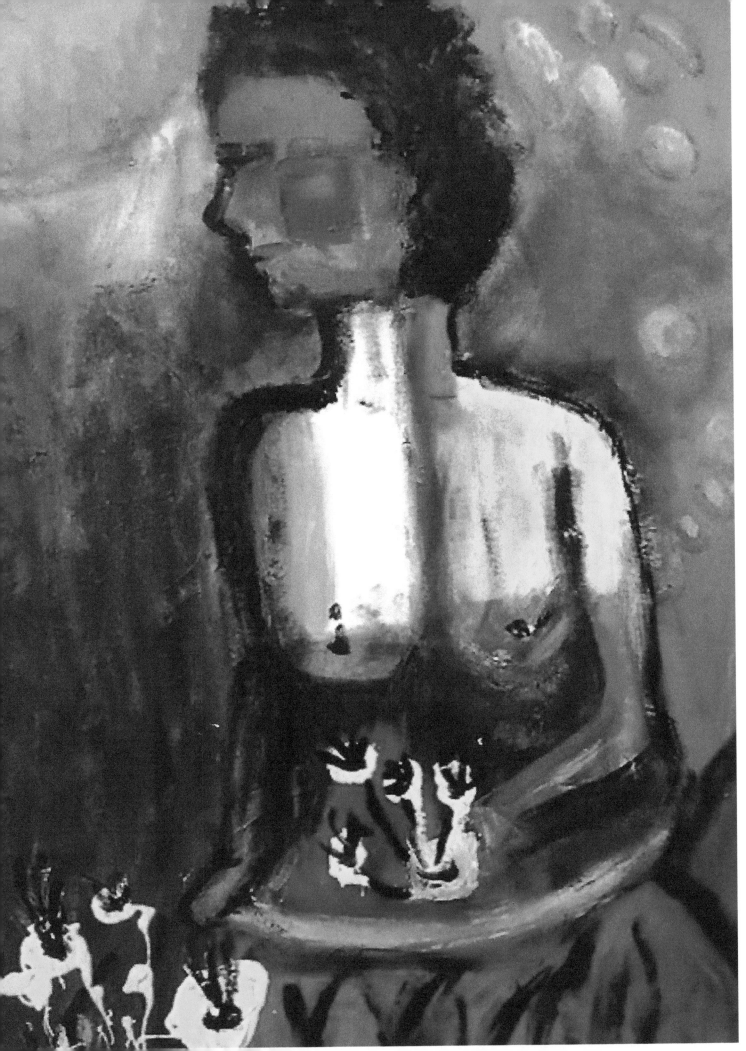

Fodder For

We hail subtle blinks

 hidden eyes capturing

 targets of cannon mouths

aimed at me and you

 filled with ruts of lonely

 day's excesses we are

me and you deeply entrenched

 acting as remaining volleys

 fodder for lies masquerading

as artifacts of happy thoughts.

Glide Through Awareness

1

the bowl that is meant to
hold water for her wash
she soaked her hands in it
gently sprinkling her face.

gazing hard she noticed
bowl a brown earthen glaze
containing not just water
but time light and space.

2

withering petal of a rose
falls from the ancient vase
to remind awareness of him
who sees eternity in it.

then it dawned on him
eternal hour is in the now
shaping what we cannot see
but which will soon be past.

Force

Oh sencelesse man, who cannot
possibly make a worme, and yet
will make Gods by dozens.
— MONTAIGNE, *Essays* (Florio trans.)

We only have to trust the wind underneath our wings that propels us when we take flight to labyrinths unfamiliar or unknown even in our dreams. It is not just an ordinary current that takes us higher than our imagination could carry us. Higher in its unbelievably protective pushes so we do not hit sharp mountain ridges. All there is to do is to trust the power of the wind to carry us safely in its protective arms so that a taste of eternity and timelessness becomes a possiblity depending on how we open up our consciousness to the dynamic of the flight. It's the kind of trust that may or may not serve the flight well depending on the uniqueness of our beliefs and perception. Thing is we can try to establish rapport with the universal force. Times are when the flight becomes fearful, the trust in our hearts somehow runs low. But tfhere should be no space for fear and doubt no matter if crises of faith sets in. The wind that bears us should fear us for our guts not vice versa. Keep on soaring high and strong until you are washed in the belief that certain points in our destination has been nearly reached. Then we hold that picture in our minds steadfastly. The force could slacken somewhat in our flight back to our own reality assaulting us with some thoughts of an abrupt fall. Fear not. That same Force that can carry us up in our imaginary flights will be the same Force that will set us down back gently on the waiting arms of Mother Earth. It is the Force we deal with everyday. Perfect in its formless form, it is the God Force.

Gape

2:00 p.m. a putrid smell of death
assailing from the ceramic room
where kept are glaring eyes that
seem to say in haste let us make
good and bundle up together what
the demi-gods left for us frail ones
to grasp with frail limited thoughts
then heal the gaping wounds not
staunchly cleaned ooze unstanched
thick blood curdling like nothing
else will quenched eternal thirst
taking over a parched throat but
we remain undefined till muffled
cries can crawl through steeled
walls that ultimately in broken
terms define our humanness.

GiveLove.com

what if we amble placarded GiveLove.com

then get pelted with mud filtered from torrential

rains wrecking havoc on things hanging around

asserting their freedom never musing on wherefores

and whys over an unurned ashes a frantic stranger

handed to him to protect because the rain was preying

on it wrapped only in a plastic sheet held close by a

keeper's keeper close to heart hiding in raindrop-spared

space save it and let alleluia gush through gaps between

teeth from tongue that's blackened and blued from mincing

words instead of a mouthed lip-curved staunch denial

notwithstanding a new site oozing with too much love.

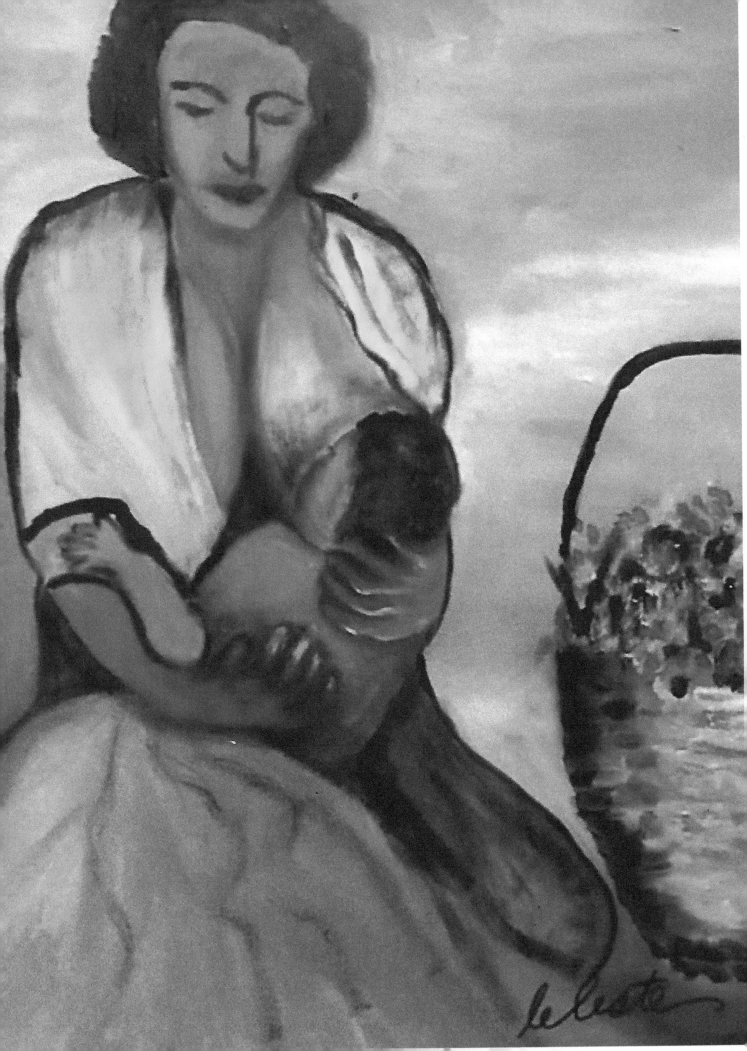

Go Live

Spin a deep-seated interlude in your silent moment.
Turn it to musical indulgence, view a painting in your
mind's eye, or plainly listen to the moment with a soul
that is open to all suggestions of the highest possible
awakening. Or take that moment to all ledges you've
been to before, dangerous, or safe. Fashion your spirit
in the thought that life is a continuum of happiness,
beauty, and above all, love. Take your self to the domain
of another love category. The difficult kind where your
heart beats even for those who seem most diffcult to love.
Immerse your heart in a cauldron that gives off a steam
which will teach you to look into the depths of your soul
seat in difficult times. Then take a retreat into a secret
chamber in your heart and let primeval solitude take over
the moment. Embrace everything life offers and learn
lessons from them. So when the soul is just about to discard
its shell, and when the green grass beckons, there should
be an affirmative to a question that has lived with us in
life. That is, " have I lived fully?" But then, only you can say.

GURU

hi Pratap! an adjunct if you will

you showed assimilations
at a time of high and dry
in bruised mornings came
barging in, rartionales of man

we are both reeking under heavy
insistent blows of truthful aphorisms
semantics are not for the meek
but let us try though caught off
guard let us try with one technique
that coils and folds by a wicket
you deem me unprepared for now
unwrap me my nasty metaphors.

but the master- a siddhapurusa
his soft voice gently engaging
bringing meanings new existencies
cutting extent of older impotence
mapping paths to nature's old ways
till I almost uncoil big part of me
the fullest self to meet the Source
heaping me a tiny snatch of light
making up unconcern for pettiness
ego approximating quantum leap
he is here but never quite here
he is everywhere can shred himself.

to be aware! said that it is!
aware of presence-drawing faith
to look hard see the tathika
seeing, a great experience.

Half of One

two days in a row
one half night
other half day
hindsights growling
in my achy joints
chalice raised
high hail marys
recited only in
chambers where
roaches deposit
half-formed eggs
 two days
 in a row
 half moon
 half sun
sanity hides in
both rooms taking
no harsh sunbeams
nor moonstreams
rundown perceptions
making a wedge a dive
between four legs falls
the whole of noon moon
whole of half sun seeking
never halfly divided
never half in other half
round mirror in hand
sick in the heads
we tangle as one.

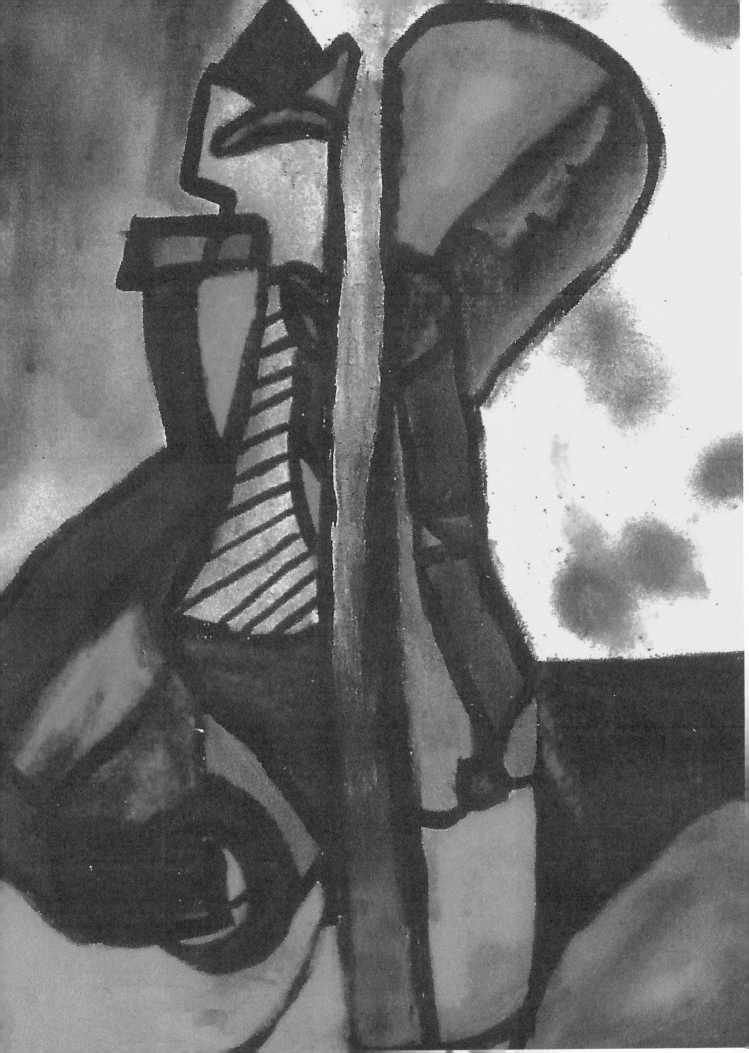

Hanging On

Most days we hang on to colored pictures
Isolate them fast from fading ones
We clean them up like milkmaids
Skimming surface of smoothened milk
Persistently with deftness of magicians
Must be prestine, untouched by the holy
Chime of time passing by uncaring
Each move to preserve them unfailing
But done with prayerful trepidition
But shall we be more afraid than the
Animated ones floating by aimlessly
There is no denying we shall all fade
Ostensibly no one stops at crossroads
To beg with open palms slow pass of
Time that doles out delusional hopes
But hunched humans swim against in
Time's measured and persistent claim.

Hey You

floating out there in space — you are riding a curved — starlight
then a beam arouses you — a cosmic intoxication — where are
you? — space does not intersect — with time thus likewise —
time unbinding itself — from space — what an error to watch —
carved clouds wanting — to seed abndoned spaces — where
mushrooms and dandelions — teem to form spokes — harvests
from lonely driftwoods — rotting sitting on shorelines —
long abandoned even — by plovers whose wings — are clipped
or missing or plainly — lying dead as in — tired dreams —
where shadows spiral — into dark steams unrecognizable —
up till we recognize — lighted figures — in lampposts where
living facts are still — not within reasonable — whack-in-the-
eye — naming but no not accurate — to remain undecipherable
bound we are at times — by fears that escape from — undefined
punctilous wounds — sustained when we go — headlong
into sharp blades unredeeming — botched willingness that —
never is anywhere near — mortgaged realities.

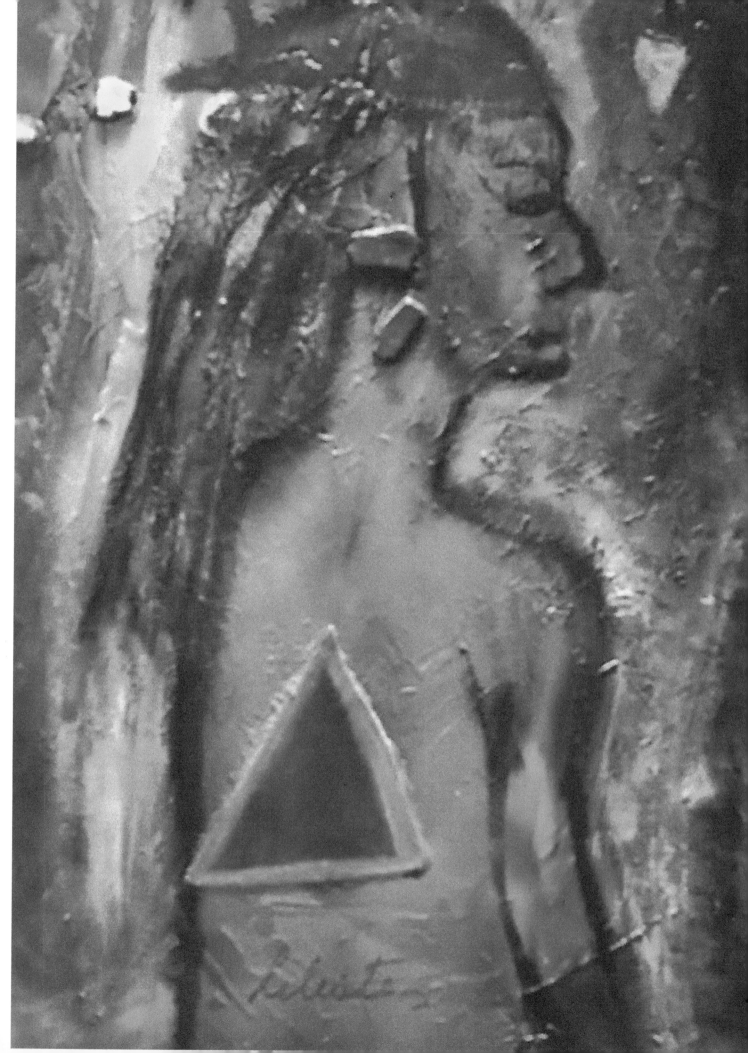

Hidden Stones

After waiting for so

Long guilt laden that the

Greenings have stopped

Despicably because for

Once there is famine taking

Its toll in some remote

Places quite hateful

Amidst blabbing wind

Telling tales of stones

And mud that are badly

Fashioned into useless

Arts in hidden galleries.

I Will

I will walk amidst clutter
flutter my wings against a raging
wind feeling its rhythm in my every bone
no chaos, just peace
and calm

I open my eyes and see
fragments of me scattered all
around like chiseled
shuttered bones dipped in
colored dust.

I Am

May I beg for some ears

My name had been obscured

I love to trek unpeopled lengthy

Tear- stained emaciating walkways

Over long abandoned tightropes

To heal braided sanity gone wrong

I am looking for my shadow

It ran away from me to random

Coastlines tenanted by disemboweled

Souls created by dancing miracles

Their fringes in hogwild madness

My body my badly fissured sanity

My whole and only half of me

They always run together fast

But they have never ever met.

In A Circle

I am moving among circles — trapped in credulous — circumference
each circle trapping me — in solid recollections — battled loneliness
of being hopelessly alone — smaller circle — caught with me — impaled
with a sharp thought — moved further up — pinnacle of doubtful curves
but as the circles spin — faster further into — an unknown alley — resting
ennuis unmoved me — now made slower by the — advent of receding —
lines made more visble — safe for the sought — after anchor — soft turns
little degrees of perfect — curves on absolute alliance — with nature's —
tricky laws made precise — so beyond you and me — alienated existencies
we never dare to know — even among broken — cups glasses in coffee bars
emblems of diminished — loves as among dead leaves — we fail to catch---
messages from winds — unwilling we are — to hear the truth that pricks —
creatures we are — in hammered loops — no bare of threads — to hang on
to — nor buckets to catch — salty drops the — languid tears to let go —
like sodden mists — they distort views — of choices we made.

In Dire Hour

fill up your questioned beginnings

with mother-milk compromises

listen-

we never outdo revelations with

energies ravaging the unlived lives

of our forefathers' echoed voices

never heard never recognized but

in our aloneness we dare shout

about for self defined identities

in airless rooms we picture frame

our everyday births so joyfully in

order to forget detoxifying sobs in

darkened rooms where death lies.

Into Strange Space

I can hardly begin now
When nights run me over
With inkless pen leaving no
Marks on my unctous skin
Galaxies in my raging mind
Shake loose burning stars
Searing wild atoms within
There is a lonely death at
Five past four in the morning
(They are murdered clouts)
Tearing pain madly felt when
Excrement of first love seeks
Deeper into core of bedsheets
Afterwards eerie love coos
Knot unfittingly with boredom
Honestly perceiving but little
Surely a chunk of our soul
Wandering slowly to strange
Stretches descalced solaces
Where flower stems are craned
Listening to intent longings
Lonely souls narrate before
Gilded altars where godly ears
Wait patiently for ages to lock
Gazes with those tearless eyes
Seizing words in unopen mouths
Muttering faith that are now into
Strange spaces lids wide open.

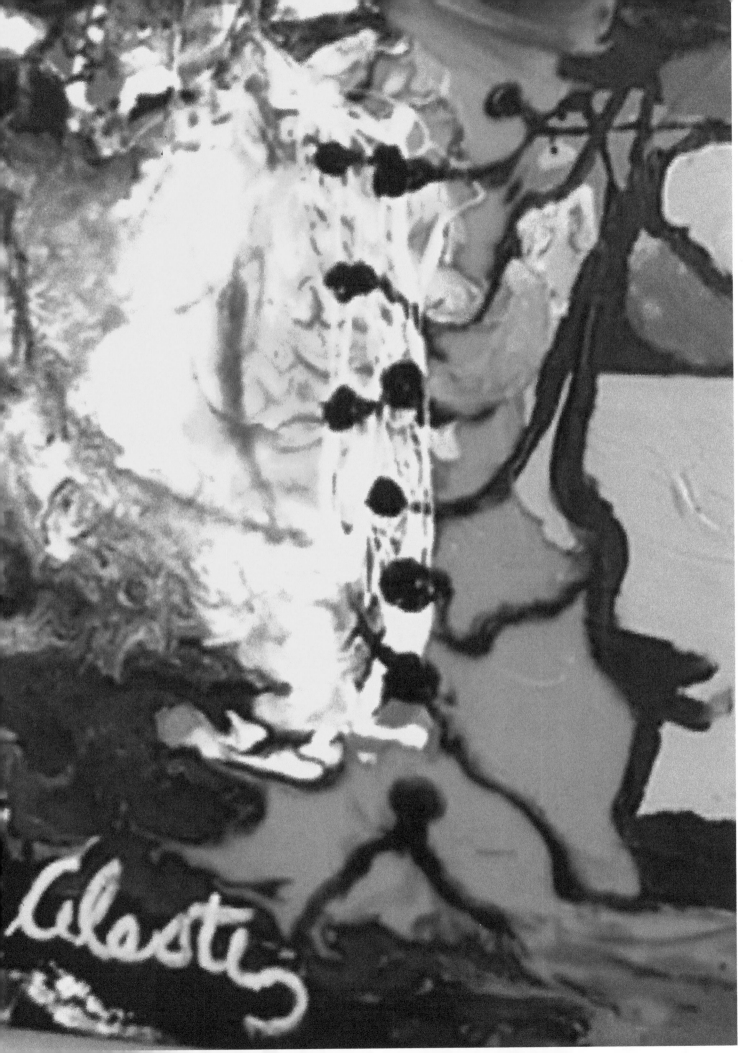

Into

So we will wade in a tiny pool as
the rains of all januaries had to
convolute around dust where green
stalks dwell for summery climbs
only days ago I long for rains
though I prefer icied ones that
shockingly send shivers down
every feeble spine as we are
made to sob tearless cries
when the cool filigree lingers
much longer than a feeble
imagination weakly offers
a smirking "rigor mortis"
in blackened bodies laid aside
by a run of stronger treks a kick
a stone unturned a sloughed
off skin deposited in debris
left by famine dead people.

Just Be

staring at nothing

a mindless

complacency

discerning nothing

a stateless

mindfulness

empty

but longing

ready

for a fill

take away longing

or take overflows

just be soaked

just be in a

beautiful

nothingness.

Keep On

now a little sand
 cuddled inside a shell
 clamped with nothing

rejection so deep so strong
 but irritant wanted to hold
 for revenge no ejection

the host insisted seen
 at least human kindness
 we need grapple with

as it departs hauled off scenes
 the eye sees what needs be
 cremated that instance

we do not wait for long
 nothing be late we clutch at
 every storehouse of

love to compliment
 the lumen and luster
 every irritant brings.

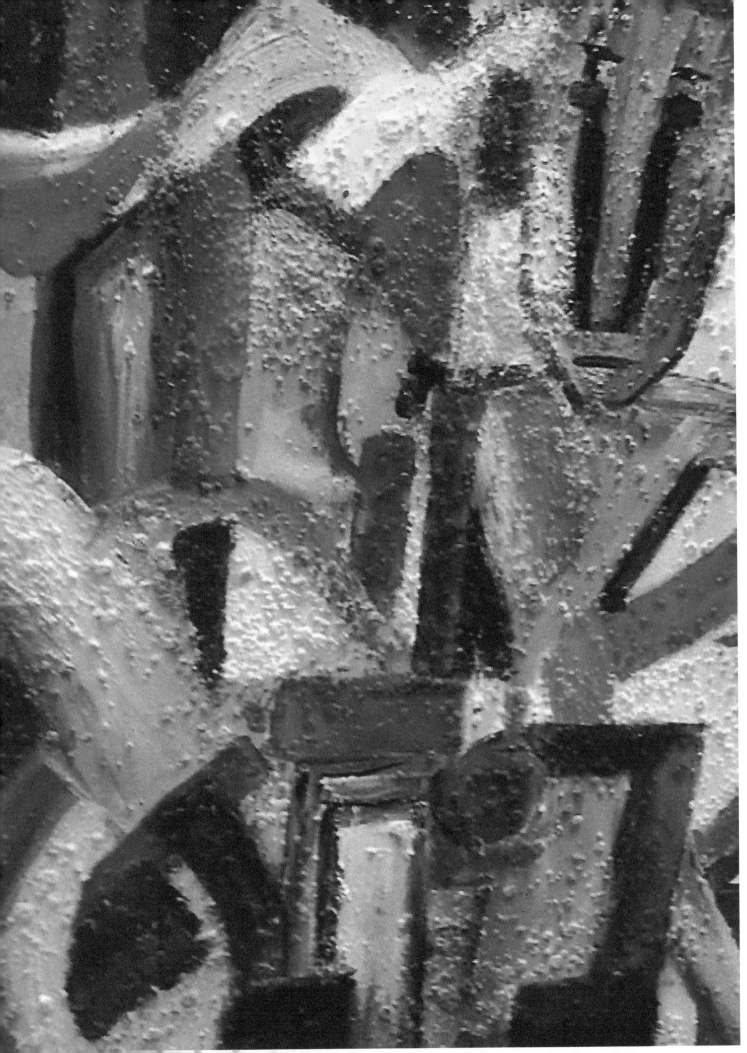

Lamentations

An irrefutable scream, oh so very
silent, it triggers an overcrowding of
solitary children, unborn our permanent companions
as we travel bound, clipped invisible wings,
locked in their own recklessness
while having been born in eternal time downward
floating with advent of drafts spectacularly
fire- worked in azure skies spewed
rainbow formed in stealth defiance
of a darkening onslaught
but the gathering gloom
likewise defies
radiated light which
was formed around
riveting swiftness that empty
themselves into
territories tenanted
by alien-faced children of a
lesser universe
they assert luminous fumes
molded from nowhere but
dead locked minds.

they have hearts that beat
in dead time-lined doggone
streets that tend
only to tough narratives
eaten out by the presence
of moths that have nowhere
to
go for lighted lamps that
go rabid on lampposts
though nothing helps,
nothing
to bail out poor
aliened relatives
you are meant to stay
depraved because the planet
that owns and conceived you
has
spun out
spun out
unreachable now at
www:planet that
self destruct.

Long After

You cannot hold
 your peace
for
 long
 after
 love
even after dreams.

Go
for
you must
 leave so

the body sheds the lust
that has been intimated
for eons by countless
 creative men to
tell your craving
 body

the desire is owned
by others too

 then you can forget
the mind is
 celebate
 and you must go
 after the seeking
shake off fiberous
longings dictated on
by prurient streaks
the body has to be
 left alone
 for now

But for how long?

Lost Words

Upon my tongue my tied up tongue

Slushy tongue slip every word

Slippery horses will run through

Several hoops but unseeing danger

Of rooting words that gallop and slip too

Over tongues of newly baptised

Early rains upon our heads

Startled heads slipping rains

To backwoods where early settlers

Dance their roots to settle to

Late morning laughters over

Nooks lesser stars cannot reach.

Morning Light

slanting morning light
 belongs in my

 early risen brain
 which knows and

 see what it does
 to my reverberating

 skull which holds
 my own share of

a universal mind
mincing twisted ideas

 and engulfs then solid
 then untangles knotted

 fibers with appearances
 of polarities like

coveted invisible light
with heavy darkness

 as they share vastness
 and thusness of present

 things hanging on to
 tidied available space

but awareness sitting
in subtle places even

 among those whose frills
 are tossed here and there

 by a stretch of running
 water on well laid brooks

gorged in hidden ground where
receding evening light belongs.

 my half-invited sleep
 starting to settle between

 uncalculated distances
 of dreams and my now

half unaware and
half awake gray matter.
half feeling brains.

My Stone

I will work on this a
solid stone to form
me my entire emotions
and when I pray and sculpt
the wanton breath of
sustained tears will start to flow
even unto riverbeds
to tell its story of becoming
one work of the hand
nourished by a heart that
reognizes beauty
nothing more
then as I align my breath to
carve my stone it will
opt for more beauty as an
insipid storm me at night
recognizes cryless
silent sobbing and
will take mark off my
ascent to highest
peaks so as to
connect with my Stone.

Naked Moves

Let me collect pestilence-infested

droppings from heavenly twisted

meridianed space skin wrapped in

naked body assembled by a hundred

silent angels conniving to taste the

flesh of a man standing by a john.

who knows what it is to sing some

arpeggios from an opera that has been

sentenced to die on shoulderblades of

women embracing their nakedness

even when we beome ignominiously

hushed and left to think no more.

someone knows the secret bud hidden

in every sin hardly defined and hardly

acknowledged by hard liners for

perfection that now lies in oceanfloors

never iron-cladly justifying every move

every naked pirouette while executing tip

toed moves that spell

murderous tricks.

Naked Puppet

You are just another heiress — to string manipulated appearances — puppets, yes —

no shit lined thoughts — no protest against skin baring acts — heaping praises said —

your naughty nod a protean sight — to lullabyed reticent whimperings — from those

who dare speak the ancient language — of gods now detached from human affairs —

spindled ripples — hanging in the skies colored blue too — skewered with sharpened

baton — speaking in swan song — gathering tunes to make a rain dance — newly clad

irises to convey the message instead — languid, besotten, asking puppets — to go

naked and more naked as — we camp at night for covert — celebrations among

hemlocks — a fragile attempt to gather words for a forthcoming eulogy on stage.

Question

Where does this weariness belong?

Tiresome acts hiding them there

In sleep we moan never to complain

But compliment half day acts concealed

Rest in artificial copy of certain deaths

Unprotesting bodies meant to absorb

Enact remains of day duplicated in darkness

We cannot see any reason as clearly

Now where does this weariness belong?

New Logic

Logic in the raw raising an arm read my roving eyes
canker in your tongue red and sore too just like your logic
when it cauliflower like bloom cuddle the core kiss it
and suck the powdered lips of those whose creeds are
saying " touch me not" with fingers that profess ancient
medusian touch directed at dead bodies refusing to rot.
Now let us navigate greed in hidden imaginations wild
languid as we braid thoughts to tie around forms of
skewed shadows then toss to fired up grills and shoo
a fly away from a sullen dog's tail unkempt squash it flat
to barebones part of creation? Now doubts to masticate us.

Epicurus
One to argue existence of gods he argued once too many
willy nilly really said in human affairs gods find no part
in their schemes of things messy weakened sensous man.

 mystical?
 boring?
 honest?
 obnoxious?
 or plain right?

My poetry
Denouement
Are we convinced? a big tear to brainless toads can they bark?
no only croak nothing to see third eye tightly closed
or is busy gathering fodders for its next round of waste
what is there to know? logic marches in the raw so for us
a must to remain naked as a fish self to dare expose
find reasons to depose or just plain consign rotting logic to
garbage doom or heaps of logic bound to rot to self
destruct in a fast moving denouement.

Night Like It Is

Miles and miles to navigate before one gets to understand what lies at the endmost stretches that belong to night. How does one make the initial step for a travel that intends to uncover what night has in store? Night has a certain kind of hushed enchantment that is very elusive. Music that is played at night takes on a distorted dissonance or euphoric impact on the hearer depending on his or her emotional state. The body or the effect of night on the body? Or is it, that only night could serve us the sublime which is hidden in the remote of time and space. Thoughts from the day's remains perhaps, that take flight at night in the form of dreams or nightmares can in the engulfing dark of night come back more chaotic or made more decipherable in the mantle of a dark night. Other dreams more exotic, some, forerunners of things to come, only the intriguing dimension of night can offer. Near morning, the sun's misty beams of light or its perennial sting? Do we smile to that or squint an eye? Haste to the wearied. The insane but pleasant innuendos of the recent past night have to be consigned to its fold. And with the advent of a bright day we concentrate on the mechanomorphic and concentric forms it is filled with. Nursed by time we become eager to measure length of day in linear terms and decide we can somehow rely on our shadows. In some segment of time, our shdows walk ahead of us or at some point when the sun is at its middle peak, the shadow gets concealed by the physical self or just hover below us, then manifesting behind us at near sunset, silently following or stalking, our shadows can be a good indicator of the relevance of time. Ah, who can speak eloquently to us about polarities? Night and day, day and night. No one as of yet has deciphered it or is willing to discuss it without extolling positive and negative qualities of the two polarities.
Conuncio oppositorum.

Not Finding

the soaring flight
toward the source
an isolating thing
a daring challenge
fear new territories
doubt sets in then
sullen anticipation
for what one seldom
meets in journeys
toward a center

between beliefs
and lurking doubts
faith keeps an eye
as flight alienates
getting lonelier as
one travels farther
blinded by a guess
the real Source may
never ever be home.

Past For You

Verily you break loose like a

shaft of glittering light

pieces of anchored thoughts

faintly humming as busy bees you

glance at happy antique clockfaces

pleasures for busy eyes locked

in rainbowed past unmoving

why decide only now

to stray into another path declaring

new footprints exposing

beating chest pulsating with life

outrunning chaotic past you want to lay

bare but cannot for now because

God was in it watching

past your mother fiercely tended and stamped

to the bare bone in you

but now many steps away from your core

hammering new truths or

newly conceived half truths

so others can deconstruct or bruise.

Posing Naked

She is naked enough to summon necessary
richness of courage to tell the world there
is a missing bone in shame that
hints about secured dreams
about one's own unowned questions
as regards the shame handed on
lifted up from ancient tales of moral stunts
that never were the marks
of truth as we try to secure
in earnest, solemn basis of
cloaked testimonies to
naked poses sold by
the hour against questions
of a genuine
exposure because
assertively
being naked
is an excuse to
truth and beauty.

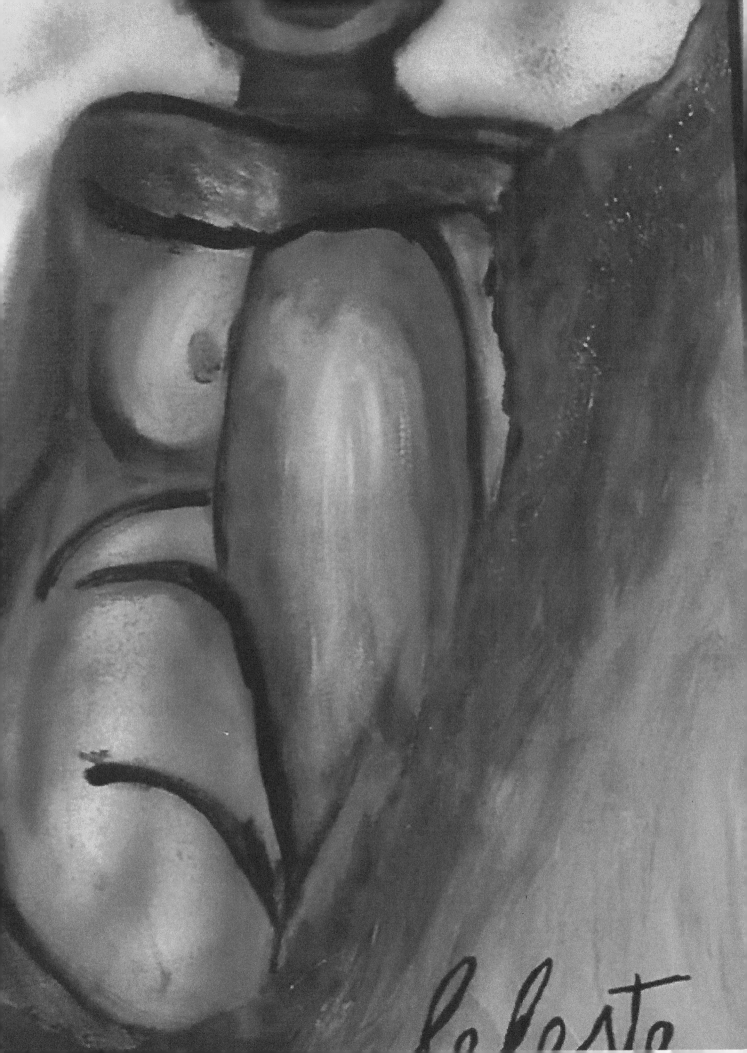

Reason

There is no redeeming factor to — a blood-soaked animal lying
on a pavement where we — walk the air viciously — seeking an
id an ego worn in our sleeves — making us look like exhausted
barbarians on a vehement — journey outward bound — away from
self — seeking honor flush a life — landscape of gore.

What reason have we
not to understand — a creature's
— logic for life?

purposeless denial — retreat into a dark room — what is in store?
somewhere waits an impending — feel for doom — it haunts part
of lacklustering memory — we once desire too — for some bloody
tales — .so can we share hurl of stones — we are all sinners —
but we think inferior blood-soaked animals — in booming canyons
the luckless ones' sole domain.

What reason have we
to go after weak heart — who
dare to believe logic for life?

Religious What?

Pool of god DNA hemmed in unfermented
bloodlines among contenders
men brandishing instinctive images
contending henchmen wearing
the ignominious masks of
a tedious other name
for chosen
a
claim for superior soil diggings
and solid markings themselves
running about to grab and
own who the hell
wants to be a
simple muck in the
armpit of truth
bending low reaching high attempt
to wring more blood from hell
for the sake
of perpetual untruth so they say
others cannot pin them
because they cripple the world tired
invoke on eared walls that
listen and store till
they decide
words can crack up world sympathies
so in some shadowed hallways
selves gutter away so they
can inherit ancient prose
resting in tongues that
speak only of
the now-a-day's relative
thoughts written away with
modern lapses of interpretations
truth is no god DNA has been
shot into curdled blood of
human content uncalibrated doses
of understated brutalities
fastened on to padded untruths
increasing the weight of
disbelief wiping away
indecisions.

Rose Petal

Looking through a glass

saw a floating flower

water tossing up a petal

here and there yelow petal

sting the eyes.

When intense lament was done

rose petal to the surface

lost emotions hurting grief

sting the eyes.

Petals tossed gracefully

beneath and on water surface

sorrow came up went down

yellow rose petal

carried sad notes

sting the eyes

then it dawned on me and decided

it is time to cease crying.

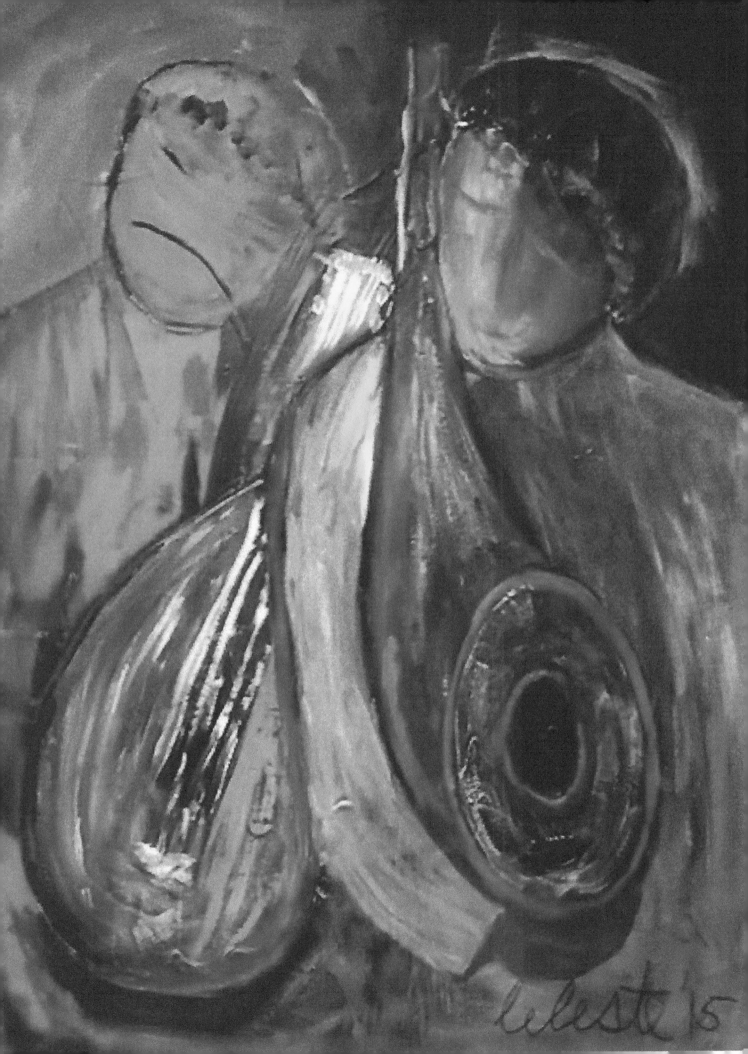

Searches

what is left of the search teetering on dsestructions
depths of the day vomitting out agenda
that never materialize that never speak
about witnessing episodes
of deep grievings
nuclear fissions made in
hell ready to serve
ready to kill
gaping holes that don't heal
that don't reveal secrets
caught from eavesdropped tales
marching as lies that gallop
in horses' mouths gagged.
Yes we know.
in featherless flights
we become autonomous
in thoughts
words
speeches
that are rammed down
unwilling mouths
so we cannot reveal what is left of
the more extensive searches.

Seeing Zen

a glass
half full
an idea
an illusion

nothing has
changed
still half
full glass

the glass
poured more
no summary
no judgement

unchanged
the glass still
half full
but overflowing

the illusion
half full
now empty
still overflowing.

Segko

Segko, your face littered with retreating stars — black hole
destined ones — you make my scrubbed skin — burn even
more like violet ashed — my eyes oozing with rain cloaked
vegetations — that had been badly chem-poisoned — only
yesterday, you see — there is a brand new commitment —
prowling around stiffened bends — so never look back at —
brined souls asking for finely tuned in — bedmating twisted like
you do — a homing run into untapped canyons — that saps
into every lap of your unctuous moves — so, Segko, you don't
piss on — immaculate whitey-washed blanket — drained then
dried and machine dried again. Segko, it is meant to wipe off —
your scruffy neck that in bed gets littered — with shouting love
bites — for who knows when necked-neck — are soon enough
boomed-a-bam — teeth bone burried on chins instead — of
thighs — then it becomes an apoclyptic — jail cell witness to
your rawness — and after the urgent love call — you will be
put in a random match — scratchy buttered lips now blackened
star-licking every fleshly — beginning start with lips and —
breasts then down your feet — how it travels fast — fuck it
that's not the end of moment — Segko, always remember —
there are holes to patch — holy lacerations to heal in our souls.

Silence

Silence stares me in the face
Me unfazed my own red rage
Burning fast through no coal
A rage made more visible
Against the mocking face of
A yellow orange moon staring
Boldly as though the silence
That settles coldly stares back
Unfazed imprisoned in burning
Embers inhabiting my chest
Deciding finally on a vertical
Spread for much-needed release.

That Is What It Is

on my way up
there ws a scheme

parlayed goods for
beggars somewhere

let us not delay
the process

it is a gory scene.

drummed up noonday
heat curdling in pools

in moonbeamed wine
jollified boat riders

my x'rayed butt
rests on a bike seat

made of leatherette
product of China?

causing me allow
the stink of wine

water soaked pencil
lead staring at me

now how can I sketch
you and your alter ego

faces that glower
allow secrets of floweres

blooming behind
my old cupboard

timidly teaming up
with scrolled orders

that as never served
goddamn restaurant

a slut spits
her damn shit

crooked beginnings
her yellow front teeth

hey, smile not for any
fucking camera bug.

old man Yayo holds
an antique cup

 for his wife to piss in

grandma is programmed
to be a hundred and two

 always hissing in laughter
 thru unclosed diastema

prayer of thanks
but to who?

 friendly bacteria died
 in her mouth drowned

by excessive alcohol
(final verdict)

 an acid mist
 her tears streaming
 down her opened wound

 a chunk of her memory
is missing she claimed

 She doesn't remember
 her current name

her ABC's danced away she said
to a hole in space where she

 crawls everynight to
 retreive trinkets her

grandmother gave her
before she passed away

 make sign of cross on
 forehead with her ashes

 time to tell story
 of her lonely birth

her father's ego was so huge
she helped him hung it

 on a wire outside
 intended to wire tap crap

Magnificent story told as a big lie.

Some Days In Jail

Hello jailed one — jam days long gone — embrace the pope's ring
still subscribe to — .long gone teachings? — say yes — but character
full tongue-twist — ...his full name — cause even holograms — reveal
nothing but an all — hollow grams a — basin full — of sleazy sludge
no blasted flesh — no sickened breasts — no larded shame...but all you
do is scream a huge — lungful air of "hello — can I poke you in your
belly button?" — allow me explore — extract burrowing maggots...that
will evntually eat — us up as P54 — to self destruct — were you not man
enough when — uniformed men came — by wearing bull shit-smudged
gun holders — I said damn it — when skirts were — in a shouting match
with a howling wind...fuck it — while a muscle of a — man wanted to
swat a firefly — unflinchingly suck the lips — of a woman's lover's thighs
then filled with withered — buds now trying — to grow new roots — new
thoughts — to harvest blood — riveting giggle — of a new blue moon.

The Road

Earlier on road was crooked

leading into the woods

 Ilusion dictating eyes what
 to see
Now: the road we walked on still

leads to the woods

 Ilusion dictating eyes what
 to see
Later: the road we walked on rose once
 undulated twice

 Ilusion
 eyes righting itself
 righting the road

But where is the road
 that leads us nowhere

 that leads us everywhere?

The Force

There exists latent in us even before birth a force which we cannot name. This force cannot be scientifically measured. It can only be felt and it resides in the deepest of our most silent center. Everything about it defies understanding and elucidation. An attempt to cultivate friendly relationship with it calls for a unique setting. We can somehow access it if we are willing to navigate the turbulent waters surrounding it and the thorny paths that lead to it. We should be willing to give up a big portion of our comfort zone and prepare to empty out our minds so we might be able to receive its impact on us once we are able to engage it. For that matter we restart as blank slates. But will pride and hypocrisy allow us to assume that stance? I am pretty sure humility has to be consigned to thin air. But are we ready to do that? One moot question, one huge doubt.

There is a dark wall we face everyday. Written on it are things we are not ready to deal with and ones we have to unveil as we go through daily ordeals. Often times we uncover self-destructive patterns which catch our consciousness and which lures us into its uncanny folds. These patterns allows us to feel rushes of adrenaline which human beings find so addictive. We wrestle with them to the point that we fail to see a patterns which offer different potentials. They are woven the other way and are very joyful. But we tend to linger more on the sad patterns. We get so fascinated by the fiery energy we derive from them and never realizing that the happier patterns with their very light energy have eluded us simply because we were not keen in pursuing them instead.

We should argue. It is healthy. You have to listen to my thesis, then present an anti-thesis. Then we will engage in a healthy exchange of ideas and work on the use of powerful words. We will exhaust all avenues that teem with reasons and at times would step back so we could get a good evaluation on the argumentative process. But we should both stay under a friendly umbrella. We should deconstruct if the situation calls for it. Only from those dissentions and wars of reasons do we arrive at some beautiful hypothesis.

To A Lover

his behavior today over breakfast
reveals of an adulterer from the
gutter while a confidential wit
hovers above a spoonless plate
then melodrama a careful mouthing

there is trouble now

"viper where have you been?"
"indeed I have to sample a sumptuous
 feast in friend's house"

such an easy thing to postpone fake
 return of a disinherited amnesia
sudden claim of remembering
"there was a funeral of a friend's
 legacy hunter father"

a tell tale colorless private joke
drips around tapping fingers
as they uncover a declining
stage performance revolving
around a proud naked dame
hunting lies between a lover's
gritting yellowed teeth.

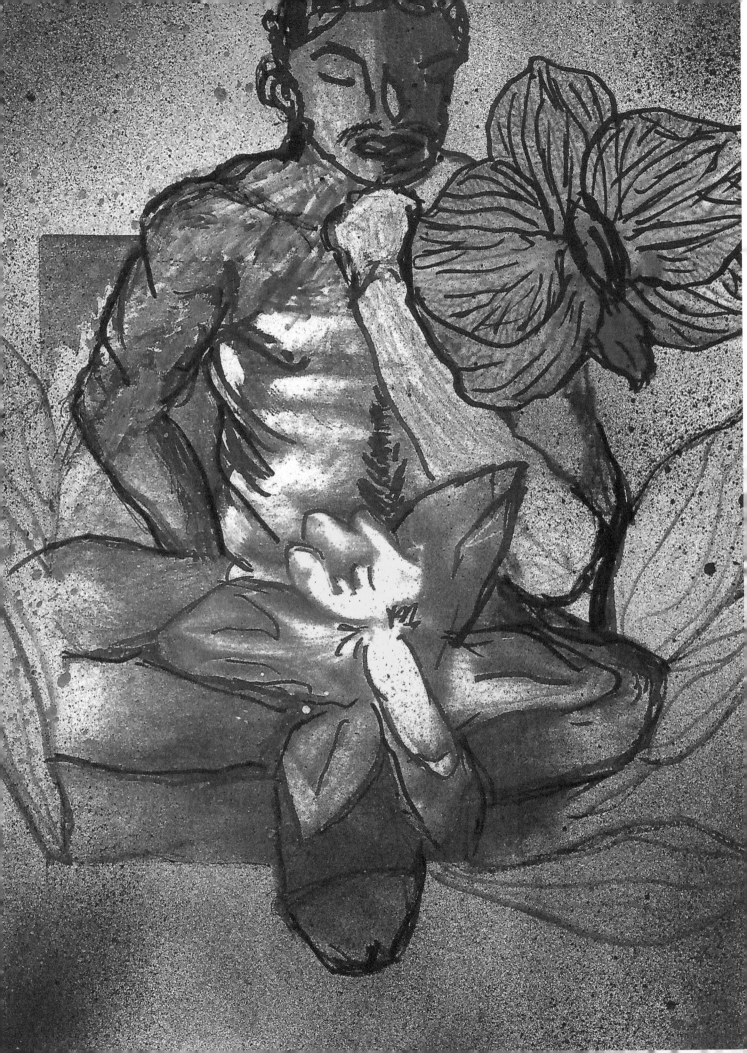

Transition

He was here yesterday
little boy crawling
upon pebbles even
munching sand

He was here awhile ago
with knee scraped from sports
gaming as he turned
into hya buff

He is here now so old
laid inside a wooden
box poised to rmbrace
Mother Earth

Truth for the Moment

slice your truth
betray no fallible feelings
freedom doesn't matter
a slice from a tree trunk

what is your story
we cannot at all stay mute
release one and then
live by and for it.

there is nothing true to
truths claimed by mouths
that echo and reecho
lines taken from bloodshed.

nothing to say much
an appropriate deal
stick to your timelines

i will grab mine.

We Do Not Know

We really don't know how to tiptoe to a muggy

riverbank as we only walk on labyrinths to catch

to hear whispered lamentations of deposed

virgins whose old loves wilted with every

sign of wrong turn then watch them create

inner passages leading to secret rooms unlit

where their cries reverberate absorbed by pitted

dreams made strong by pursuits that speak

of destructive patterns but shaped by gods who

see beyond bleak distortions in every hunched man.

We Do

We create jumbles in our heads with juxtaposed landscape of thoughts. Those thoughts, they rapel down mountainsides instead of finding unkempt pathways. We are physically provided with organs such as noses which enable us to categorize smells coming from the caring bossom of Mother Earth. Ears so we can enjoy the sound of lullabyes she sings through bird songs and melodies created by the winds that whizz by even when we are fast asleep. We have eyes to feed in the shimmering colors dancing away from the sun's magnificent rays and the trees and flowers that catch the rays likewise. Most important, we have the hearts to love what is beautiful and exotic. But sometimes, the enthusiasm is nowhere to be felt. We fall short on the ability to enhance the tools that enliven our relationship with life. We sometimes fail to develop an eagerness that will allow our souls to soar high and dive back to the nurturing arms of Mother Earth scathed, hurt then fly again the vertical fly of adventure, fly back home and everytime more hurt more scathed but richer in experience and knowledge each time. Each dive back to earth creates deep scars and torn tissues but they are beautiful marks of deep learning and well founded confidence and power.

What If

we glide on to the edge — which seems vanquished by — the
fearsome clutch of time — in a perverted act as — if nature doesn't
give a damn — a shit — no excessive downstream — flow to embrace
a wild piece of architectural — lump in wailing walls — to meet the
constant whirr of — rusty drill now honing — bound to keep an —
obsessive eye on design — that will suit tailored to — every mood
every distant thought — collected though never — divulged because
it spells nameless act — of desecration fearing — top people fashioned
some secret rooms — in pyramidal norms — leading to sacred paths —
only tainted minds will — later brilliantly spell out prayers — for new
generations to see and cope — the intended meanings.

What Is Going On?

White bouquets attached
to pews wanting to see a bride
but not a shadow yet.
What is going on?

Pews are neat at 1
marching should proceed
before then nothing
not a dull footfall
What is going on?

Someone has to lend voice
collected lyrics waiting
on pew pockets who
knows what they say
What is going on?

No choir no singers
nothing but questions
hanging on to shimmery
shadows of quiet.
What is going on?

There was this last repast
between two people who did not
know meaning of abandon
one unable to move to the union
so they chose death without the
other in the absence of
love they could not stand
parting but ultimately
had to.

What is going on?

What To Do Towards End

Let us gather brown leaves
That relate long stories of fall
Covering warm tales of summer
Gone rushing to a near close
Waiting on wintery onslaught.

Come closer and slowly breath
Me your being's earnest desire
Bring me diagrammed dreams that
Come in morning time when sun
Light makes a descent with its dust.

Dark hazes laying still in the night
Scampering for places like there is
Nowhere to settle on except around
Cloud lids to wrap tightened in nooks
With the inching presence of dawn.

Let us then gather brown leaves
That remain on the ground unblown
Yet waiting for a windy toss as first
Sign an eternal cyclic deed of our own
Distress signals occuring at winter time.

Come closer and with a still heart
Be glad to wear a well rested mind
Now is the time to embrace cycles
Sun's heat, moonlight, rains to embrace
Tough reminders cycles of life and death.

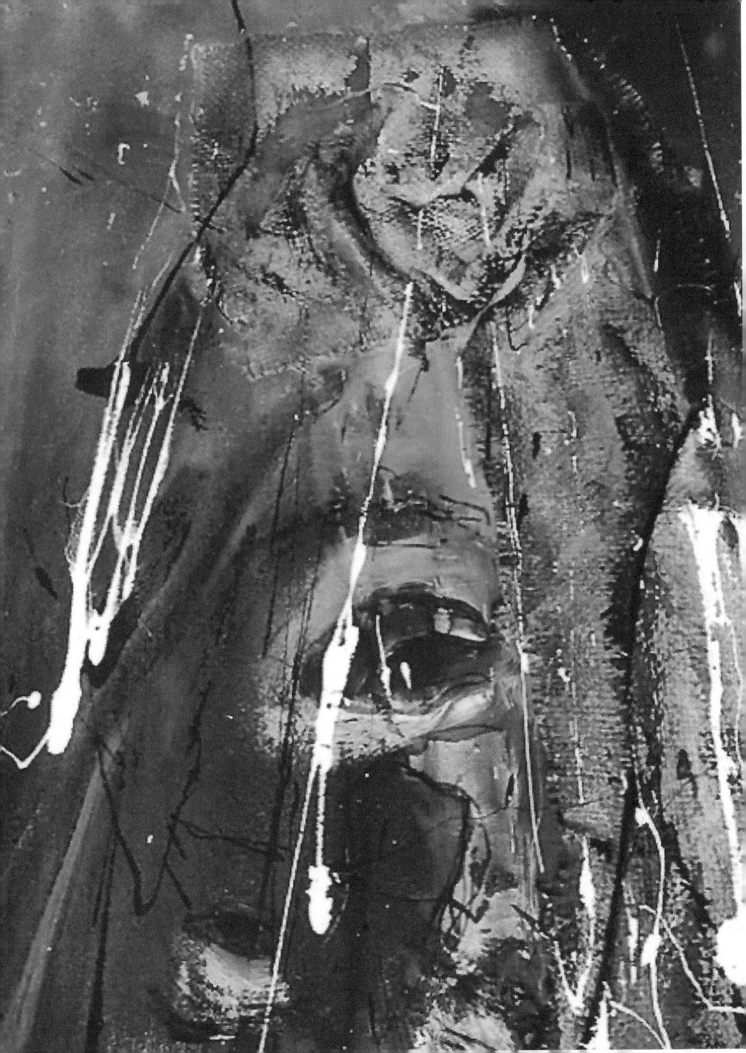

What Truth?

Scale walls then slide down right back
 explore labyrinths then echo every loot
 hold on to blood-filled umbilical cords
 munch on but where's your truth
 what have you seen so sacred
 not a hair for microphone.

what have we got for the seasons
 what makes the frog croak?
 in its nightmarish dreams in sleep
 it doesn't think with its head
 so we can leave it alone.

nobody can ever surmise
 baggage brought in by fingers
 of easy sunset or sunrise
 we can only at best guess
 proscribed gluttony at hand.

facts are severely half-cooked
 doled out by a Force who sets
 out mined truths for us to choose
 I will hone mine from so many
 from feeble ones a tug-of war.

let us carve a thousand paths
 that lead to sparks in atomed thoughts
 challenge or desist up for us to gloat
 derision I will take or with a lance
 skew home nearest truth.

Who We Are

We are our grandchildren's friends
Whose voices we are not keen to hear
But secrets of milieu we hardly share
We can even for long buried skeletons
Of memories exchange timid tales of
Ashes from that of laid away ancestor
Whose wisdom roams around halls in
Tightly lidded urns where etched are
Gloom, doom tattooed in bones that
Never knows what it is to shout from
Towers where the ancient bottles are
Thrown into barren fields that do not
Measure strength of seasons gone
And whose landscapes are unchanged.
We only have dead hands now
Half buried in rain soaked sands
Taunting sun-baked riddles that
Are brimming in every dead head
Stashed away somewhere nobody
Knows about because every now
And then we have to be part and
Parcel of many rains and moons.

Yes We Do

We allow humanity to sink in

not when we fuck in dark

and smelly alleys then

be buried in puke and shit.

No not in that manner: Rather

We allow humanity to sink in

when we rush out to receive

harsh blows and parry not

teaching us to reconstruct.

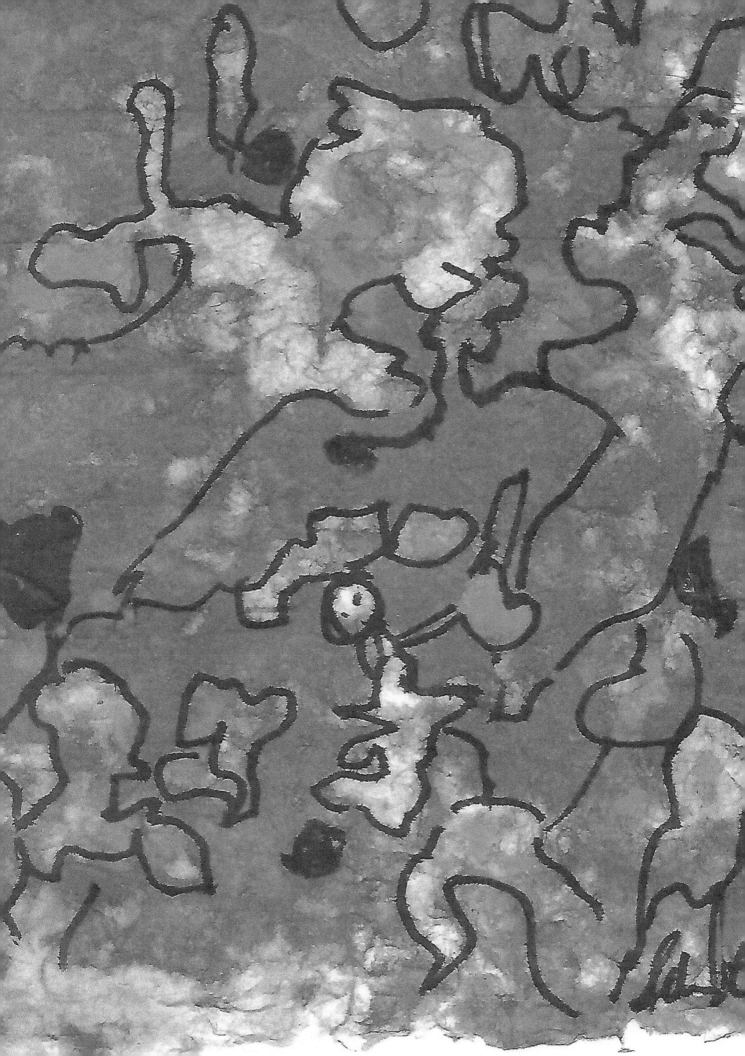

Zelma?

Ah Zelma you run around not unlike a broken horse
gobbling up fly traps unmindful but your mind conjures
winding down to an ever yawning gap littered with your
clayey puke. The wanly forced word- tricks rammed into
your abscessed throat are hardly minced oh holy ghost
there are new sounds latching on to pavements watching
for the rising heat that need be locked in jars then left
to ferment in sidewalks till it smells of dozens demi-gods.
Wake up fast and furiously to the sound of new tones then
catch them and feed your cats and dogs with them to fully
masticate innocent brains unadulterated by-lines filled
with unborn worms to eat them up then spew out cuds
stretches windings backward aimed to gag sticky moon
then feel what it is for your naked foot tickling pallette
an aching mouth cotton filled but bleeding chewing some
garbled truths. Zelma? Your brain has to be served raw
in a tray so the wild beasts can pick on it then let your
hidden legs speak some truthful truths. Allow potent
lies be buried under creaking beds. Lick with your
swollen tongue love's excrement hear creaks pruriently
announcing perfect rhythmn tempo between two hips
bound by lust in morning to save night after horny
excesses. It is illicit, or is it not? That's great. So when you
smoke your last cigarette release tobacco smell not let it
wander to underclothing sting cling so that in the morn
tobacco air will out drown every trace of lust
that happily sustains usual games of the gods.
Zelma?

110

Zen Minding

mind embracing each

moment never succumbs

to onslaught of thoughts

that are now bound to eons

past like:

 the chair

my father sat on

for thirty years

has changed a lot

my father still sits on it

it is still the same.

An Artist's Mind

As an artist, I sometimes have the apprehension of approaching a blank canvas. I would stare at one from a distance with deep reverence coupled with a good deal of trepidation. Looking at it with an open heart and mind, I would experience a strange feeling of a heart-rending anticipation on what it will ultimately reveal. My boggled mind would then imagine endless routes to a thousand images. Sometimes I would find myself in a semi-awake state trying to descend into an even more serene and deeper point in the center of my being only to be aware of a galloping wild thrill toward an unexplainably savage and extremely more chaotic rank. I would dwell on it for some electrifying moments and the images would sometimes become my poetic narratives thus erasing the thin line between my poetry and my paintings. Then a commingling of the two. I would then silently tiptoe into the blank canvas. It is as though my sanity gets hemmed in by the rays of imagined colors emanating from it. Postponing to give birth on canvas of an image excitedly born in the mind as a result of an encounter with a blank one, is to me a sacrilegious act that would make me break out in my head and compromise the sensitivity of my artistic calling. Never acting on the artistic flare of the moment would also muddle up my mode of expressing it (have to keep clutching on or I would lose it). I would not let that moment go by without examining the artistic aspect of its every detail which sheds light on the fact as to why sometimes such artistic sparks drive an artist deliriously happy, detached, isolated, and rarely understood. So that it would become for him or her a temporary but a very delicious form of madness once the unique call of an artistic moment is seized. Armed with my brushes and other painting paraphernalia, I would tiptoe into the canvas very silently as if I would miss its hidden and sacred message if I am unable to prevent making unnecessary noise in my every step. I would try to establish a relationship with the untouched canvas. Then with a calm settling, with the first stroke of my brush and the first kiss of color on it, I would feel like everything is falling into the fold of a beautiful ritual. It then becomes a revelation, a solemn, prayerful indulgence. With an image coming on, my hands are guided, my mind awash with joy, my heart steeped in a spiritual age- old covenant only an artist understands fully well. It is always so, that an artist should render to the world, truth only as his or her innermost being feels and perceives it.

— Celeste

(January, 2019)

CPSIA information can be obtained
at www.ICGtesting.com
Printed in the USA
FSHW010157090119
54901FS